"*Our work of art is a scream of freedom.*"
–Christo and Jeanne-Claude

Christo and Jeanne-Claude in New York City, February 12, 2005, on the opening day of their public art project *The Gates*. Partners in life and art, they were both born on June 13, 1935.

COVERED in COLOR

CHRISTO & JEANNE-CLAUDE'S
FABRICS of FREEDOM

written by
Elisa Boxer

illustrated by
Susanna Chapman

Abrams Books for Young Readers

New York

Christo's world swirled with color.
Bright, bold color that popped off the pages of books and into his imagination.
Stars and shapes and designs
danced off each page.

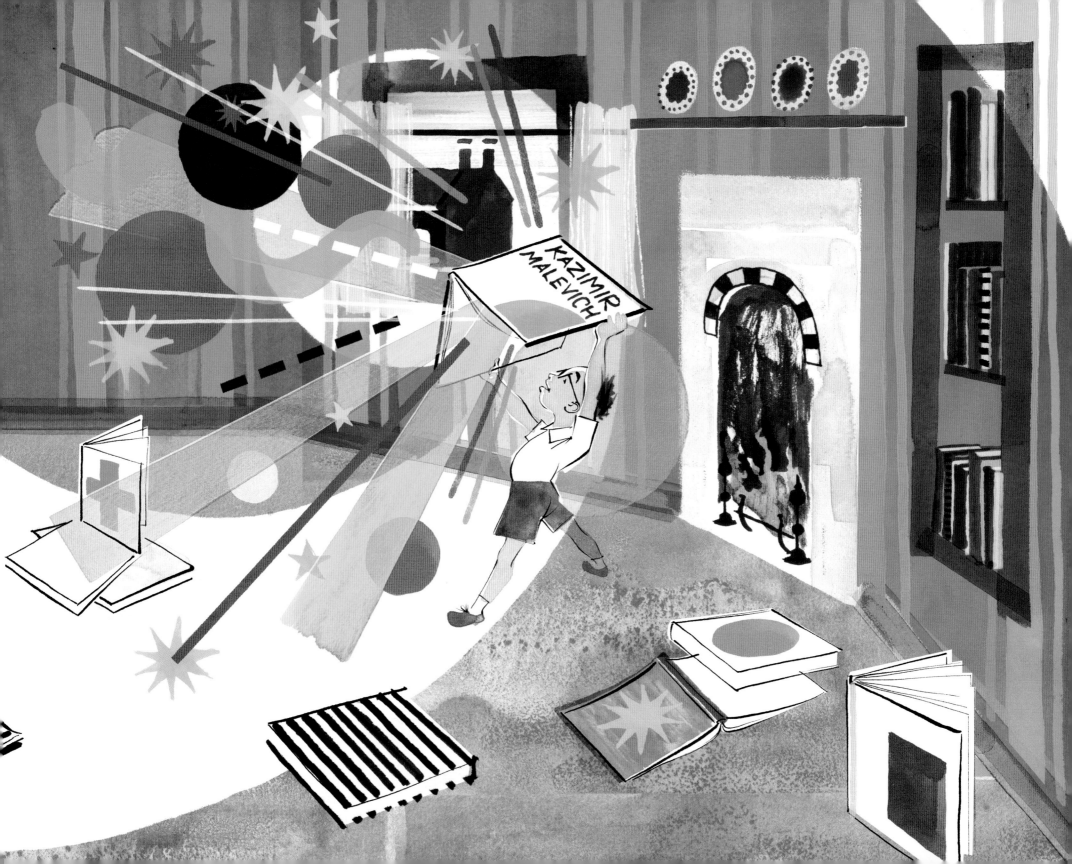

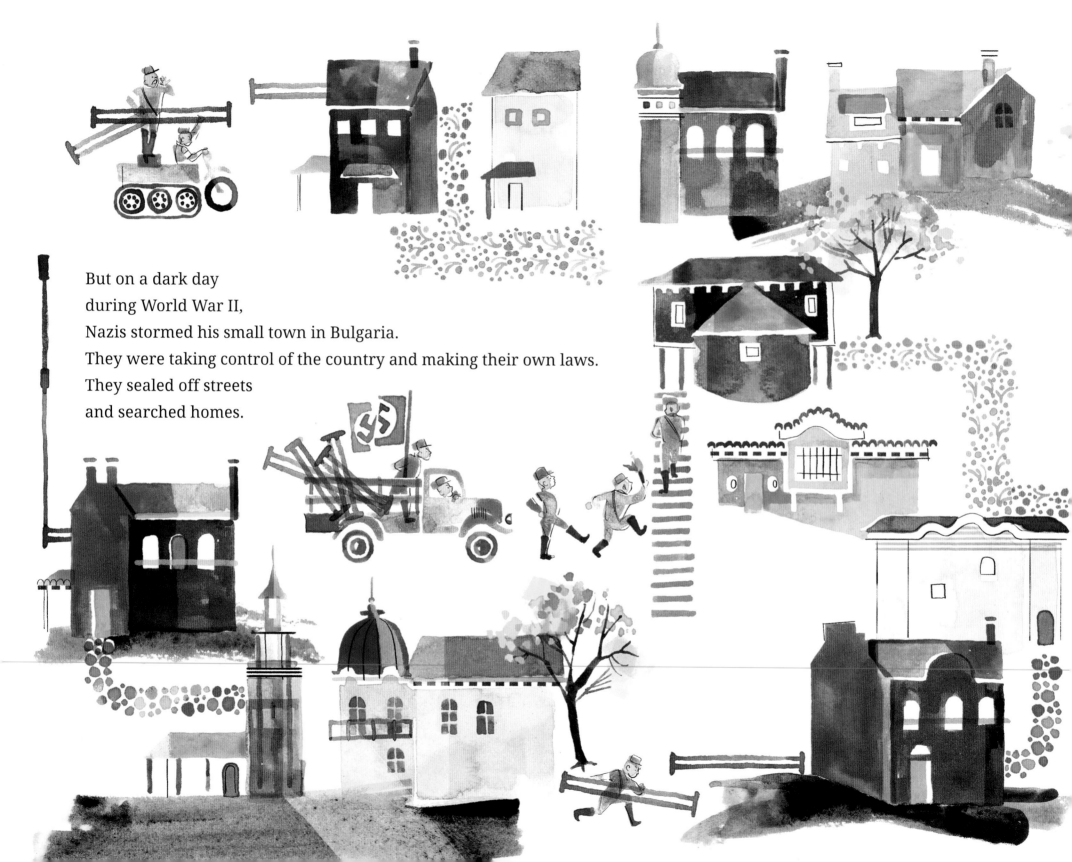

But on a dark day
during World War II,
Nazis stormed his small town in Bulgaria.
They were taking control of the country and making their own laws.
They sealed off streets
and searched homes.

Christo's parents panicked.
The books—
the colorful books with stars and shapes
and designs that danced off each page—
those books broke the rules.

No! Christo pleaded with his parents.
But he knew they had no choice.
The Nazis came to round up anything
that went against the new laws.

Christo watched the flames erase every trace of his treasured books.

That was the day his world lost its color.

But it ignited a spark.

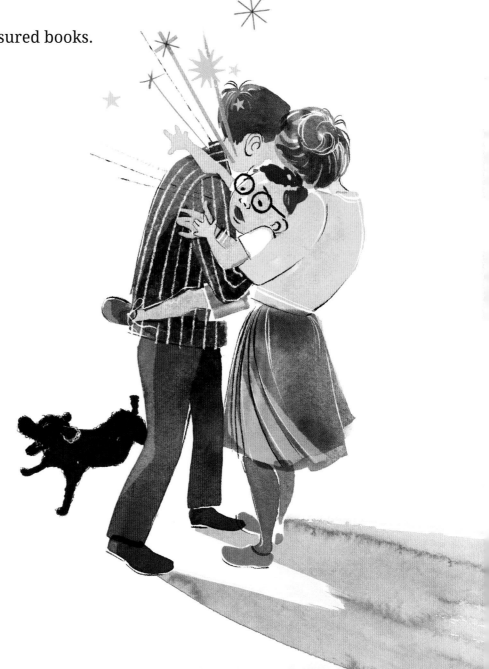

Years after the war, Christo enrolled in art school.
His brush became a bridge
between his love for the land
and his creativity on the canvas.

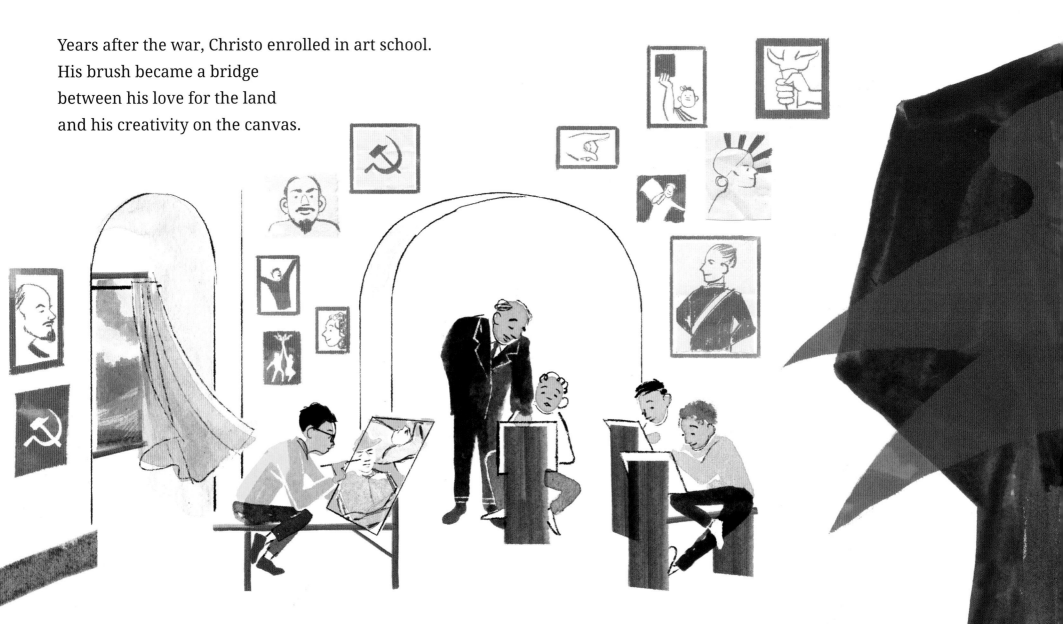

One painting he was particularly proud of:
farmers resting in a field after a hard day's work.
Christo captured their exhausted expressions.
The teacher was furious.
How dare he depict people looking drowsy?
It didn't matter that the farmers *would* have been tired
after tending their crops all day.

The Nazis were gone, but a new government was now in control:
Communists.
They, too, had their own rigid rules.
They only wanted people looking pleased.
No room for honest faces or feelings.
They forced artists to paint propaganda:
pictures designed to make the government look good.

But Christo longed to paint life as he saw it.

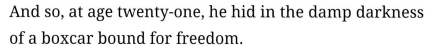

And so, at age twenty-one, he hid in the damp darkness
of a boxcar bound for freedom.
He had to sneak over the border, past the Communists, to France—
where people were free to live as they wished.

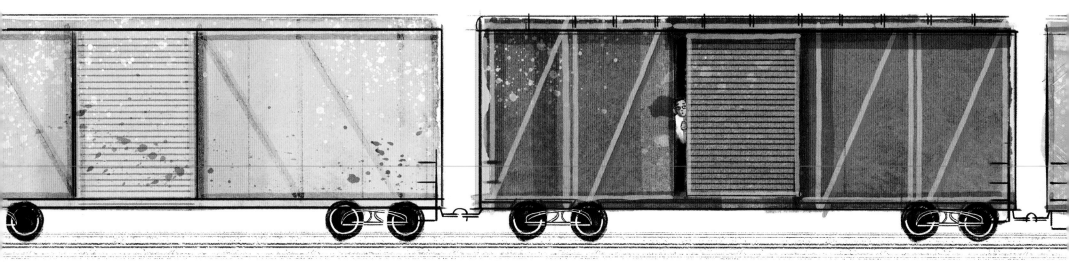

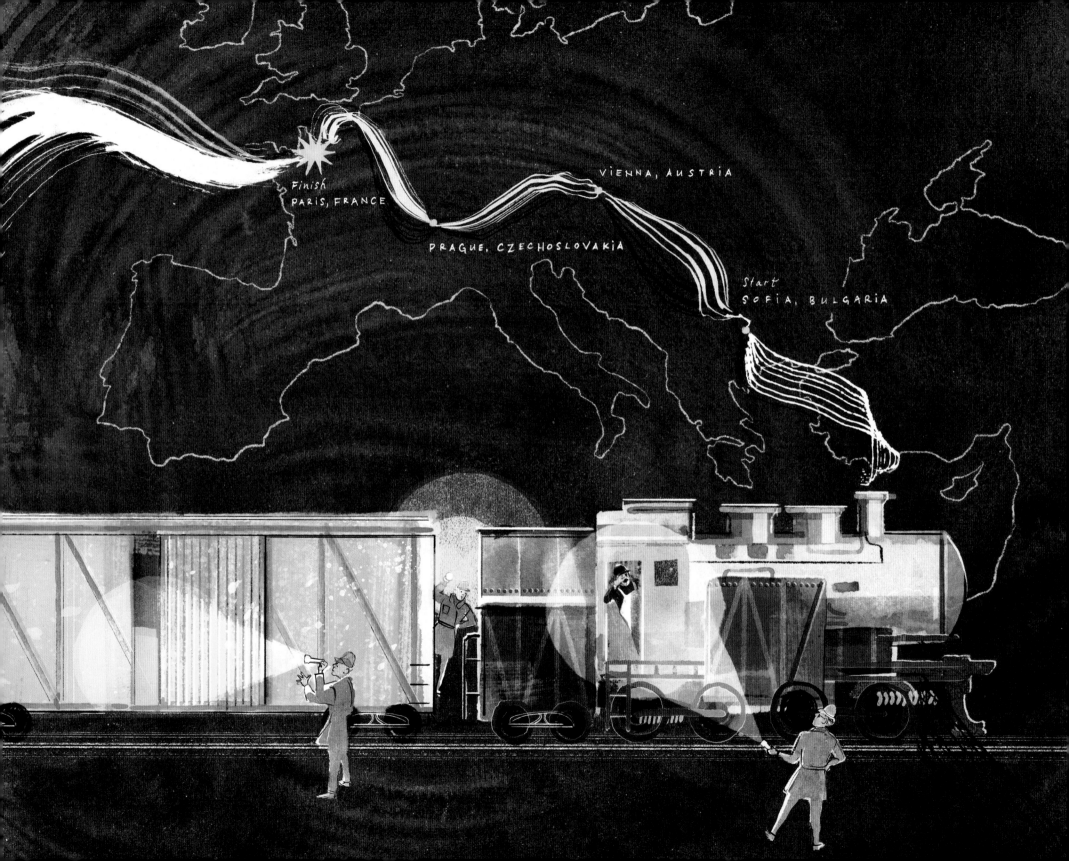

Christo was poor.
But the city of Paris was rich with colors and the possibilities
of making whatever his mind could imagine.
Like sculptures!

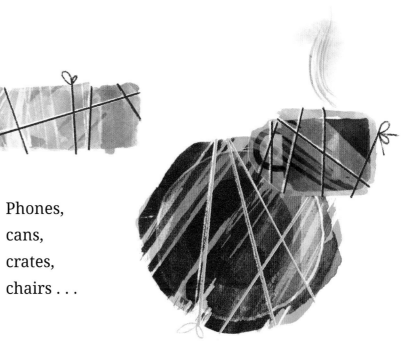

Phones,
cans,
crates,
chairs . . .

he wrapped them in canvas, tied them with twine,
coated them with color.
Christo's creativity was coming alive.

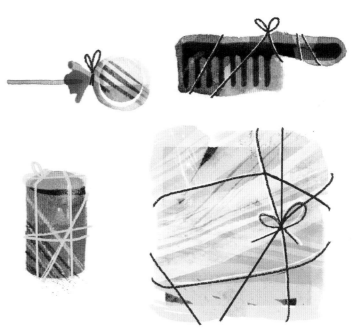

He made money on the streets,
painting portraits of passersby.

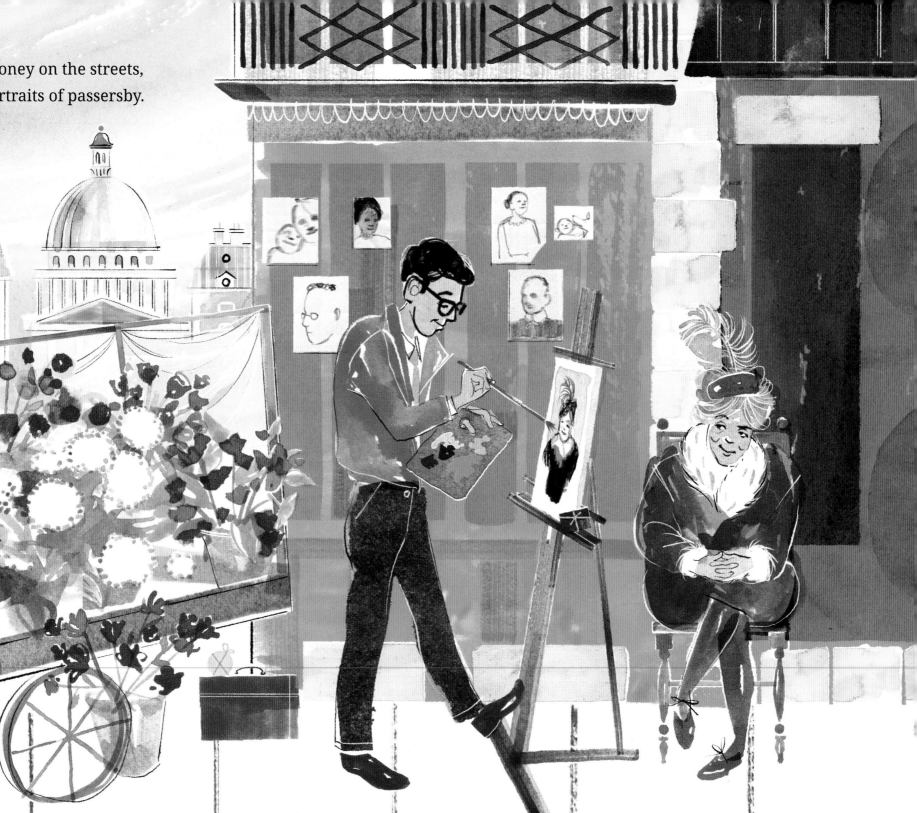

One of them invited Christo to come to her home.
She had a daughter
with flame-colored hair and a birthday
in the same month, of the same year, on the same day,
during the same hour as Christo's.
Her name was Jeanne-Claude.
They fell in love.

They decided to start a new life together in America.
From the bow of the SS *France*,
the Manhattan skyline stretched out before them like a canvas.
An idea began building . . .

in charcoal pencil,

then in collage,

then in conversation

with the owners of two of the city's tall buildings
that Christo and Jeanne-Claude wanted to wrap.

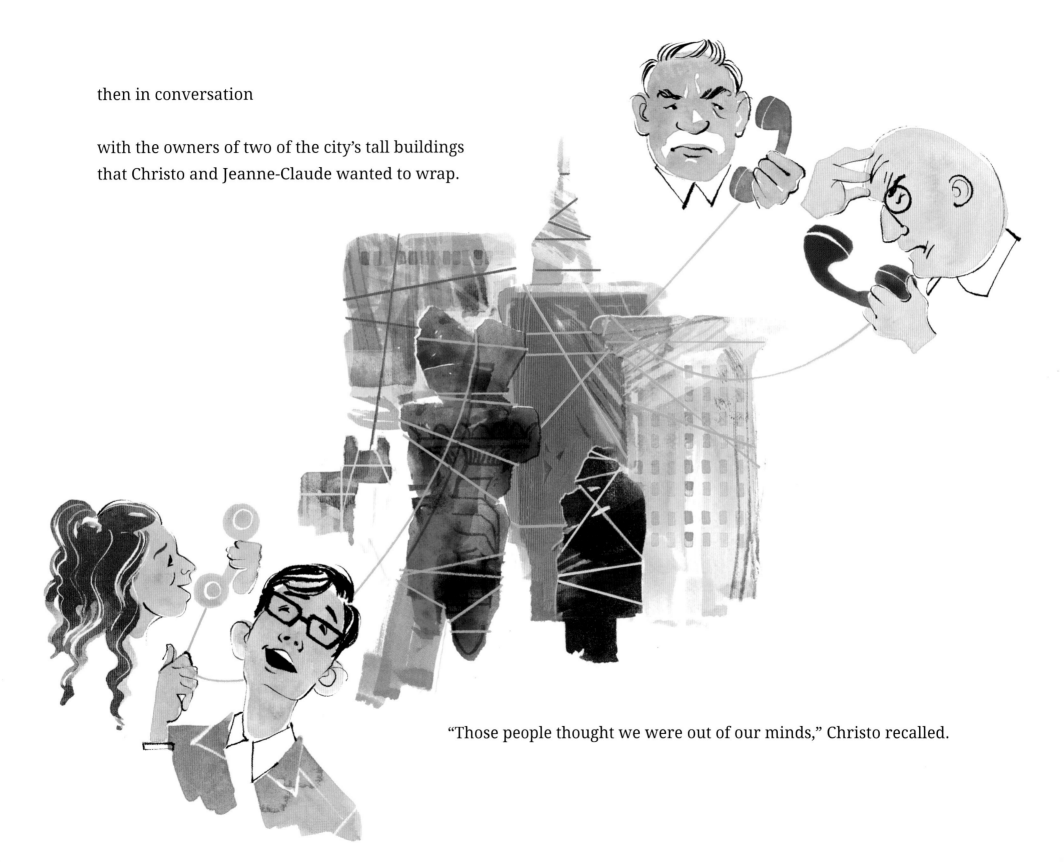

"Those people thought we were out of our minds," Christo recalled.

But officials in Switzerland didn't.
They welcomed the idea of a swaddled structure.

Wrapped Kunsthalle
SWITZERLAND, 1967 - 1968

Twenty-six thousand square feet of fabric later,
Christo, Jeanne-Claude,
eleven construction workers,
and two miles of rope
enveloped the museum Hamburger Kunsthalle.
Their first wrapped building.

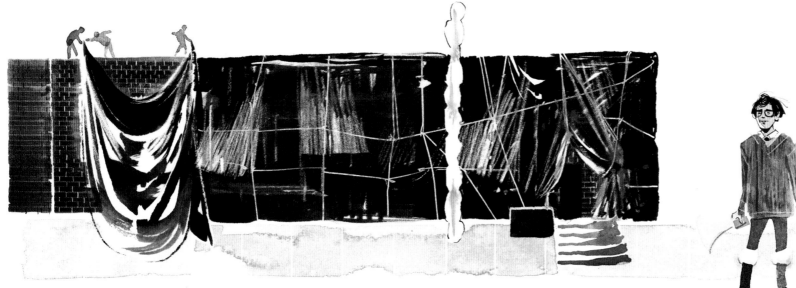

Wrapped Museum of Contemporary Art CHICAGO, 1969

But it wouldn't be their last.

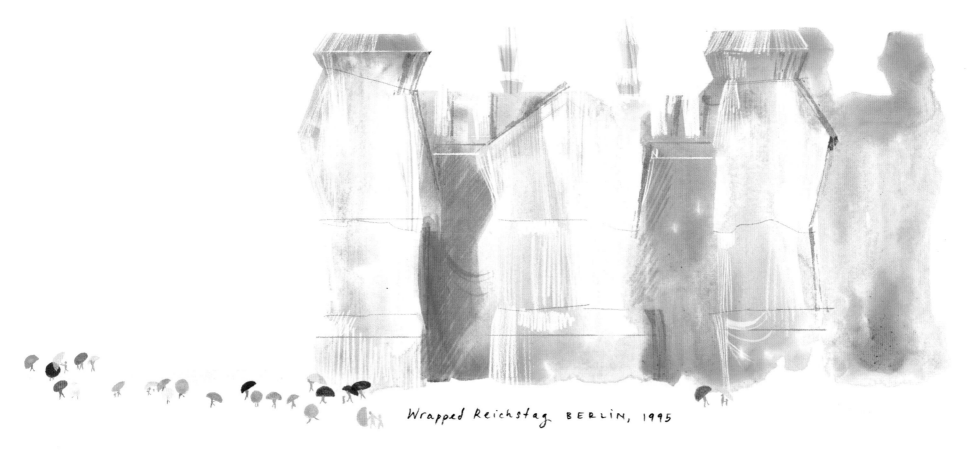

Wrapped Reichstag BERLIN, 1995

Their creativity could not be contained.
They wanted to wrap rocks . . .
cliffs . . .
the shoreline of an entire coast!
But everyone said the same thing:
"A coast cannot be wrapped."

Christo, Jeanne-Claude, and one million square feet of erosion-control fabric disagreed.
The shoreline along the Australian coast stayed wrapped for ten weeks.

Longing to transform more of nature's limitless lands,
they turned their attention back home to New York City.
To Central Park.
They saw a spacious swath
of fertile ground
waiting to come alive with color.
Christo put it on paper.

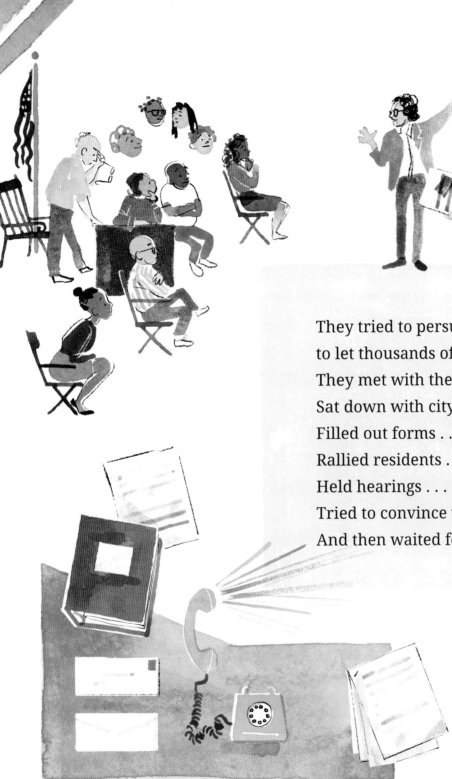

They tried to persuade people
to let thousands of orange flags fly.
They met with the mayor . . .
Sat down with city planners . . .
Filled out forms . . .
Rallied residents . . .
Held hearings . . .
Tried to convince the community . . .
And then waited for official word.

NO.

A 107-page rejection called it "the wrong project in the wrong place at the wrong time."

So they colored other corners of the world.
In *Surrounded Islands*, which Christo called their "pink project," he and Jeanne-Claude hired 430 workers to help them surround 11 islands east of Miami with 6 million square feet of fabric.

Like all their art, this was temporary—
woven with a sense of urgency to be seen before it went away.
They spent two and a half years creating it, and took it down
after just two weeks.

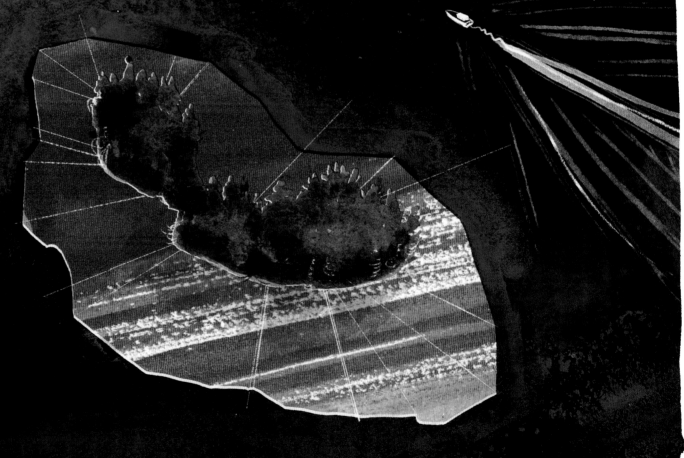

Surrounded Islands Miami, 1980-1983

Eight years later, more than three thousand
yellow and blue umbrellas unfolded in
California and Japan—
splashing the lands with surges of
color and symbols of shelter.

The Umbrellas JAPAN & USA, 1984 - 1991

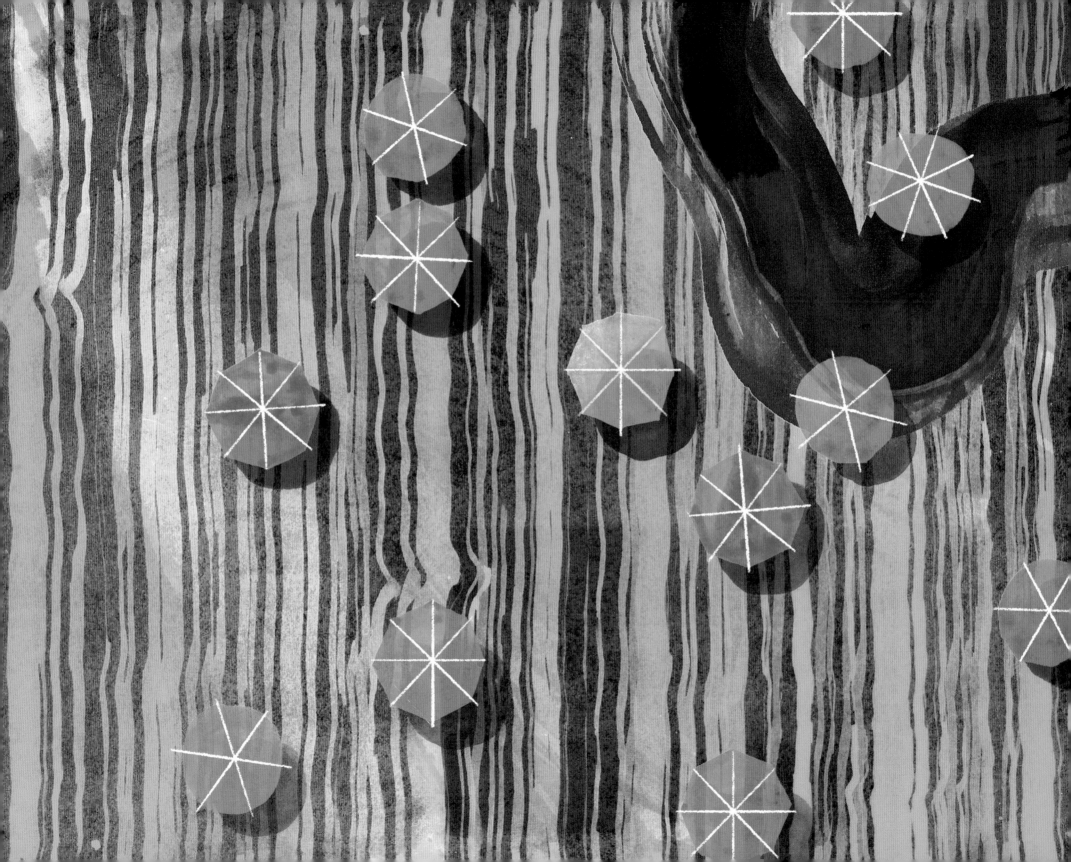

But they couldn't stop thinking about Central Park.

As the years went by, they kept sitting down with city planners . . .

Filling out forms . . .

Rallying residents . . .

Holding hearings . . .

Trying to convince the community to let those orange flags fly.

Once again, they waited for official word.

YES!

Twenty-five years after they first floated the idea,
the mayor of New York City announced that "the patient efforts of Christo and
Jeanne-Claude, who would never let go of their dream,
have finally been realized."
The mayor called it "the most exciting work of their legendary career."

For two weeks,
millions of visitors streamed into Central Park
to gaze up at the orange flags forming *The Gates*.
For twenty-three miles,
one million square feet of fabric
hung from more than five thousand tons of steel.

When the wind and the light were just right,
the cloth panels would touch together,
creating an orange ceiling of sunshine.

With his wild, wide-open creations,
and with Jeanne-Claude's help,
Christo freed himself
from the repressive governments
and their rigid rules
in the lands he had left behind as a young man.

With bright, bold fabric that cut through the cold of February like a flickering flame, he released himself from the Nazis' cruel rules.

With creativity cascading through Central Park in a sea of saffron, he unchained himself from the confines of Communism.

Like all of Christo and Jeanne-Claude's work,
The Gates would soon be gone.

They compared the fleeting nature of their work
to rainbows
and other temporary wonders.
"These are valued because we know that they will not last."

But their art does last
in all the ways that matter.

Covering the globe's landmarks and landscapes
in brilliant color,
with art designed to end,
they leave a legacy
that lives on.

What would compel someone to cover entire structures and swaths of land in fabric? When setting out to research this book, I was particularly interested in the significance of the wrapping. My mind went to places like: Swaddling? Security? Protection?

But rather than uncovering any specific significance that Christo and Jeanne-Claude wanted their work to impart, I found the opposite: Like so much notable art, theirs was about opening up to individual interpretation. They wanted meanings and perceptions as unique and varied as the individuals witnessing their work.

They wanted their art to belong to the world. No one ever had to pay admission to see it. It could never be owned by anyone, so by default it was owned by everyone.

The concept of Christo's artwork as free, open to interpretation, and available for viewing on a wide-open scale stands in stark contrast to his childhood, which was marked by the extreme suppression of individuality and creativity.

Christo Vladimirov Javacheff, who used only his first name professionally, was born in Bulgaria in 1935. He was drawn to art at a young age, especially to his parents' books of Russian literature, featuring avant-garde art. "It was beautiful," he recalled. But it soon became forbidden. In 1941, German forces crossed into Bulgaria, and Russia became the enemy. A defining moment in Christo's life came one year later, when the Germans blocked off the streets and searched house by house for anything that could be seen as Russian propaganda. "I think somebody told them my parents had these books," Christo said, "and my father burned them before the German army arrived at home."

It was the beginning of a childhood marked by severe suppression. After the Germans lost control of Bulgaria in 1944, the country came under the Communist rule of the former Soviet Union's Red Army. Everything became nationalized—owned and controlled by the government. No more private property allowed. Christo's father owned a textile chemical company that was raided and taken over by the Soviets, who also kicked them out of their house.

As a young student, Christo was a talented artist, but was only allowed to draw what amounted to socialist propaganda. Wanting more freedom to explore his creativity, he enrolled in Bulgaria's National Academy of Arts. But there, too, he was forced to create only art that glorified Communism.

He moved to Czechoslovakia, hoping to find a safe place to work. But the Hungarian Revolution created a dangerous environment for artists, so he stowed away on a train bound for Western Europe. After brief stays in Austria and Switzerland, he settled in Paris in 1958, where he began wrapping small objects like bottles, cans, and stacks of magazines.

Struggling to learn French and earn a living, he made money by painting portraits of passersby on the street. He met his soon-to-be-wife Jeanne-Claude Denat de Guillebon when he painted a portrait of her mother. They became partners in life and in work. He was the artist, and she negotiated the deals. In 1960, they had a son, Cyril. Four years later, the family moved to New York City as undocumented immigrants.

That same year, a gallery exhibited Christo's first work: a wrapped air conditioner. His use of fabric as a way to earn a living had officially begun.

No work epitomized Christo and Jeanne-Claude's artistic journey more than *The Gates*—a project twenty-six years in the making. After numerous sketches, countless collages, much ridicule, and multiple rounds of rejections, in 2005, they transformed Central Park into a sea of saffron for two weeks.

The *New York Times* reported, "In the winter light, the bright fabric seemed to warm the fields flickering like a flame against the barren trees." Looking at photos of *The Gates*, the flickering flame image stood out unmistakably to me as well. And I was taken back to that defining moment in Christo's childhood, when he watched his beloved art books burn.

From wrapped buildings to draped walkways to fabric-covered fountains, mountains, and islands, Christo spent the rest of his life creating outside the confines of a childhood contained by war and repressive regimes.

This also explains why he often said the democratic process leading up to the projects was as much a part of the art as the art itself, even if the process ended in rejection. Most of Christo and Jeanne-Claude's projects took years to come to fruition. There were permits to be filed, environmental impact studies to be done, landowners to be lobbied, and public hearings to be held. There were always negotiations, debates, and the free exchange of ideas that stood in stark contrast to the world Christo experienced in his earlier years.

And of course, even for the projects that were rejected, Christo always had sketches, collages, and sculptures to show for his efforts, which were then sold to private collectors to fund the bigger projects.

Christo and Jeanne-Claude never accepted donations or sponsors. Their public art was funded entirely thorough the sale of Christo's smaller-scale work. And while that work is still housed in museums across the world, Christo and Jeanne-Claude always emphasized that their large-scale public art was, in fact, designed to end. Which is ironic, of course, because such wild, wondrous, temporary works stay forever in the hearts and minds of all who see them.

ARTIST'S NOTE

When I first saw Christo and Jeanne-Claude's *The Gates*, I thought, *I've never seen anything like this. It looks like fire. It's a flowing dress. I'm seeing through the curtains of seven thousand windows.* It didn't look like a massive project that took twenty-six years for two people and a large team to plan. The project felt alive, like the bold flames had suddenly ignited all over Central Park.

Years later I walked down the street and saw big tarps being tied around a bridge. Bright blue folds billowed in the sun. *Could it be Christo and Jeanne-Claude . . . again?* I looked at the shape of the wrapped gift where the familiar bridge had been, the wind inflating and collapsing the tarp as if it were breathing. Then I saw it was not an art project—the bridge was under construction for repairs. But I knew I had seen something exciting as I waved at the construction workers.

Christo said about his and Jeanne-Claude's projects, "They exist only because myself and Jeanne-Claude want to see them." Christo and Jeanne-Claude gave us wild things to see and a different way of seeing, but they also gave us the example to make and do what we'd like to see but have never seen before.

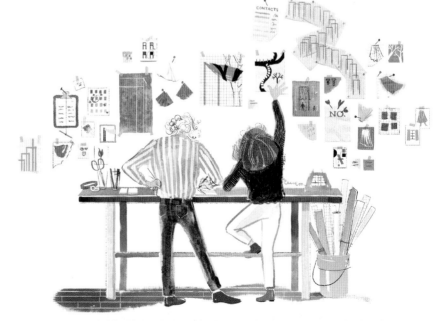

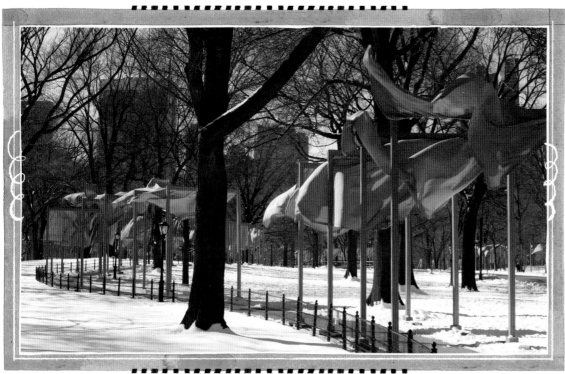

The Gates, *February 2005, New York City. First proposed in 1979 and finally realized in 2005, the sixteen-foot-high steel poles and nylon curtains spanned twenty-three miles of Central Park walkways. As was always the case with their art, once the installation was taken down, all materials were recycled.*

L'Arc de Triomphe, *September 19, 2021, Paris, France. After fleeing Communist Bulgaria, Christo moved into a small room in Paris in 1958, overlooking the Arc de Triomphe—a monument commissioned by Napoleon to honor French military victories. In 1962, as a young artist, Christo made a photo montage of the Arc, imagining how it would look if he could wrap it. Although Christo passed away in 2020, he made arrangements for the project to be completed posthumously. From September 18 through October 3, 2021, the Arc de Triomphe was wrapped in 7.4 acres of recyclable polypropylene fabric, by a team led by Christo and Jeanne-Claude's nephews.*

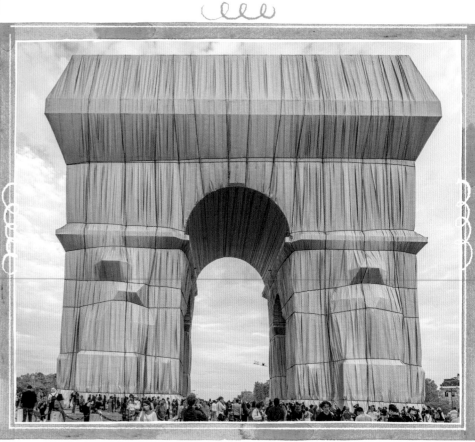

NOTES

"Our work of art": Sotheby's, "The Final Christo." See sothebys.com/en/digital-catalogues/the-final-christo.

"Those people thought": Jonathan Fineberg, *Christo and Jeanne-Claude: On the Way to the Gates, Central Park, New York City* (New Haven: Yale University Press, 2004), 174.

"A coast": Fineberg, 169.

"the wrong project": Michael Kimmelman, "Christo's Billowy Visions, Fleeting but Unforgettable," *New York Times* (June 1, 2020). See nytimes.com/2020/06/01/arts/design/christo-appraisal-gates.html.

"pink project": Dea Cvetković, "Surrounded Islands: Christo and Jeanne-Claude's Famous Pink Landscape," The Collector (October 30, 2020). See thecollector.com/christo-and-jeanne-claude-surrounded-islands.

"the patient efforts": Press release from Mayor Michael Bloomberg (November 22, 2004).

"the most exciting work": Bloomberg press release.

"These are valued": Dr. Doris Maria-Reina Bravo, "Christo and Jeanne-Claude, *The Gates*," Smarthistory (August 9, 2015). See smarthistory.org/christo-and-jeanne-claude-the-gates.

"It was beautiful,": Fineberg, 164.

"I think somebody": Fineberg, 164.

"In the winter": Michael Kimmelman, "A Billowy Gift to the City, in a Saffron Ribbon," *New York Times* (February 13, 2005). See nytimes.com/2005/02/13/nyregion/a-billowy-gift-to-the-city-in-a-saffron-ribbon.html.

"They exist only": Christo, quoted in *Walking on Water* (documentary film), dir. Andrey Paounov, 2019. See bit.ly/christodoc.

SELECTED SOURCES

BOOKS

Baal-Teshuva, Jacob. *Christo and Jeanne-Claude: Basic Art Series 2.0*. Cologne, Germany: Taschen, 2016.

Fineberg, Jonathan. *Christo and Jeanne-Claude: On the Way to the Gates, Central Park, New York City* (Metropolitan Museum of Art Series). New Haven: Yale University Press, 2005.

Koddenberg, Matthias. *Christo and Jeanne-Claude: Urban Projects*. New York: D.A.P./Verlag Kettler, 2018.

Volz, Wolfgang. *Christo and Jeanne-Claude: The Gates*. Cologne, Germany: Taschen, 2005.

ARTICLES

Capps, Kriston. "How 'The Gates' Triumphed Over New York's NIMBYs." *Citylab*, March 2, 2020. See www.citylab.com/design/2020/03/central-park-nyc-public-art-gates-christo-jeanne-claude/606589.

Gilbert, Sophie. "Christo Found Beauty in Realizing the Impossible." *Atlantic*. June 1, 2020. See www.theatlantic.com/culture/archive/2020/06/christo-dead-84-found-beauty-temporary-monuments/612499.

Glass, Nick. "The Artist Who Wrapped the Reichstag Will Take on the Arc de Triomphe Next." *CNN Style*, May 23, 2020. See www.cnn.com/style/article/christo-interview-new-york/index.html.

Grimes, William. "Christo, Artist Who Wrapped and Festooned on an Epic Scale, dies at 84." *New York Times*, May 31, 2020. See www.nytimes.com/2020/05/31/arts/christo-dead.html.

Kennedy, Randy. "The Gates Unfurling to High Hopes." *New York Times*, February 12, 2005. See www.nytimes.com/2005/02/12/arts/design/the-gates-unfurling-to-high-hopes.html.

WEBSITES

Artnet: www.artnet.com/artists/christo-and-jeanne-claude

Guggenheim Museum: www.guggenheim.org/artwork/artist/christo

Official website of Christo and Jeanne-Claude: christojeanneclaude.net

For Dad, whose bedtime stories filled my world with color. And ignited a spark.
I love you.
—E. B.

For Farve, who plans his projects so beautifully
and is always eager to help me plan mine.
—S. C.

The illustrations for this book were made with watercolor, gouache, a rare pastel or marker, and Photoshop.

Photo credits: Title page: Christo and Jeanne-Claude; photographer: Shawn Ehlers/WireImage via Getty Images. Page 41: *The Gates*; photographer: Ernst Klinker/Alamy Stock Photo. Page 45 *L'Arc de Triomphe*; photographer: Franck Legros/Alamy Stock Photo.

Cataloging-in-Publication Data has been applied for and
may be obtained from the Library of Congress.

ISBN 978-1-4197-5611-5

Text © 2022 Elisa Boxer
Illustrations © 2022 Susanna Chapman
Edited by Howard W. Reeves
Book design by Heather Kelly

Printed and bound in China
10 9 8 7 6 5 4 3 2 1

Abrams Books for Young Readers are available at special discounts when purchased in quantity
for premiums and promotions as well as fundraising or educational use. Special editions can also be created to specification.
For details, contact specialsales@abramsbooks.com or the address below.

ABRAMS The Art of Books
195 Broadway, New York, NY 10007
abramsbooks.com